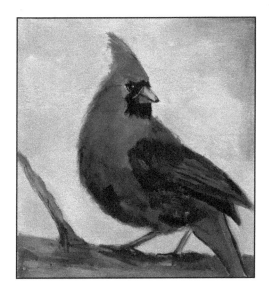

Here I am.

jodi hills

A message of love, carried on wings.

Jodi Hills Publications
New York Aix en Provence

Jodi Hills is the author and illustrator of 15 award winning books.
She sells her original paintings worldwide, currently living, loving and creating in the south of France.

—To all those who fill the skies with love.

Jodi Hills Publications

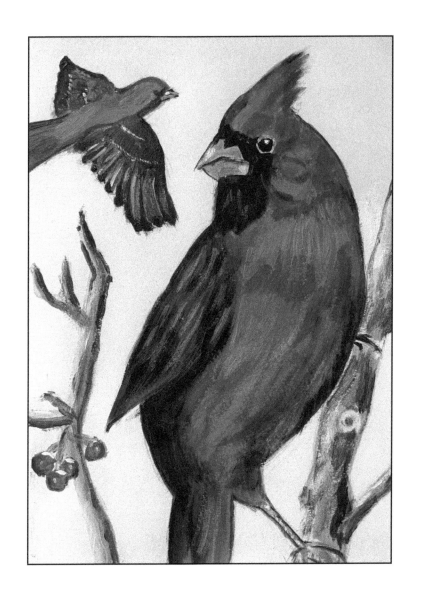

I saw you the other day.
The sun was shining.

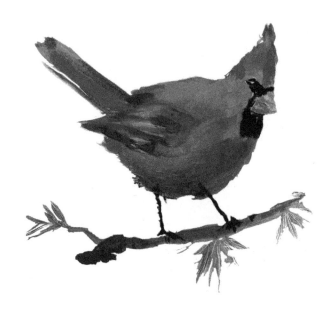

The ground was solid.
You planted each foot outside
the door, as if it were
the first time.

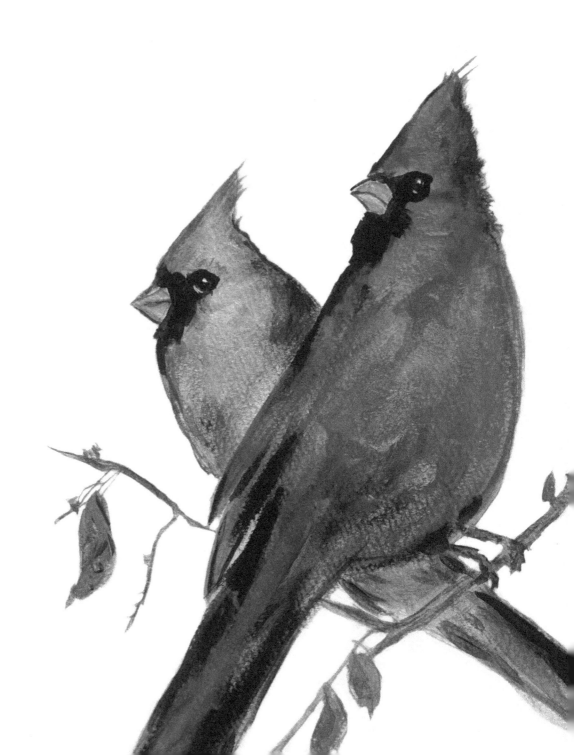

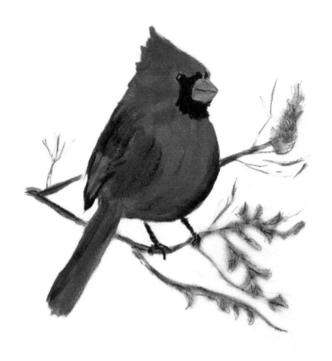

You took a deep breath,
and I did the same,
as if to help you take the next.

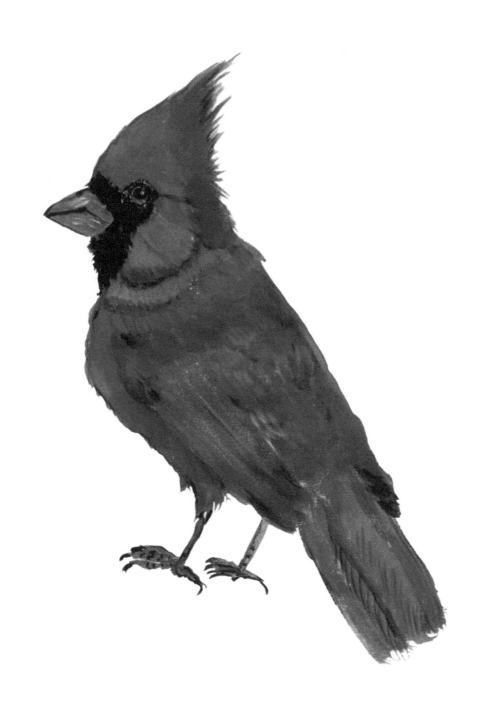

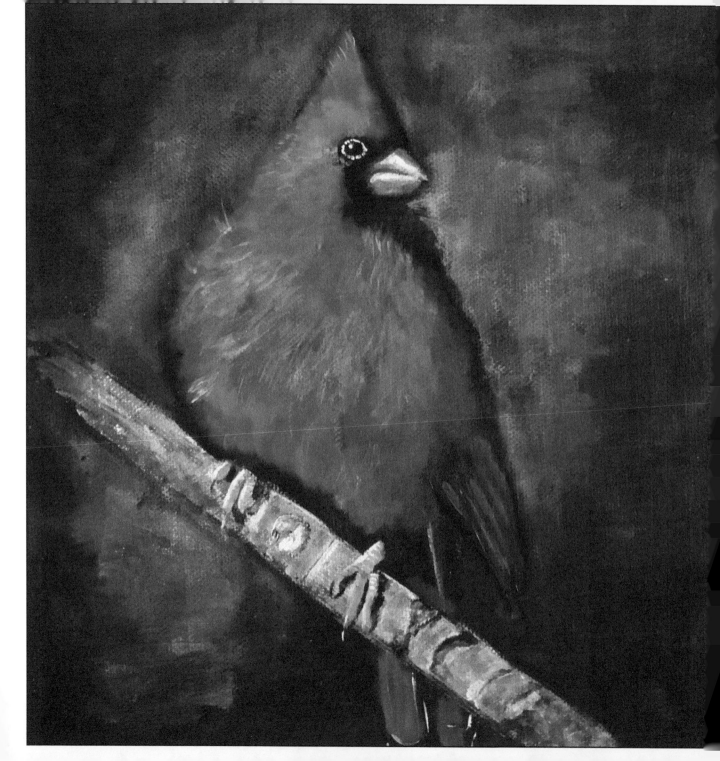

And you did, slowly.

I wanted to fly down and
gather you in and give you
the view from up here.

The view that says it's all OK.
The view that says don't worry, be strong.

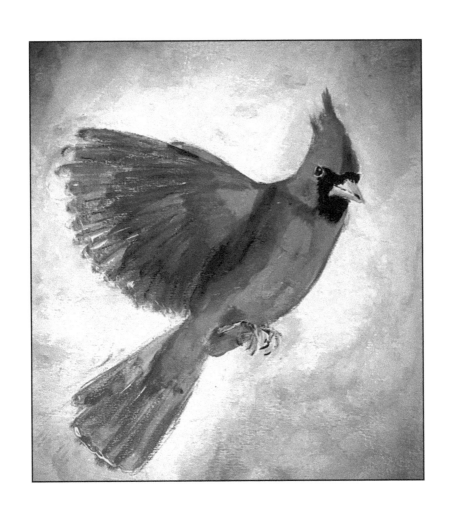

Not to say all is right with the world,
when is that? I've never seen it.
But most is good. Most still is
good, and that is my view, from
the sun, the blue, down to you.

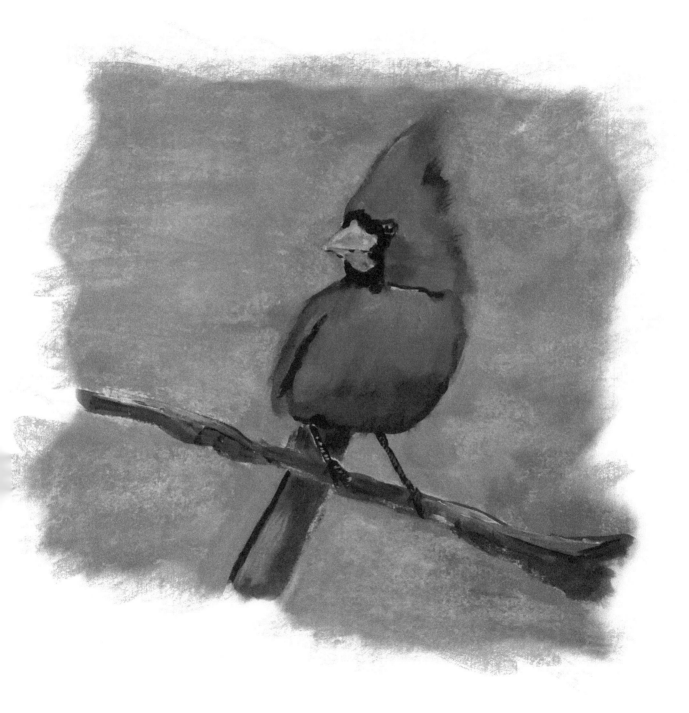

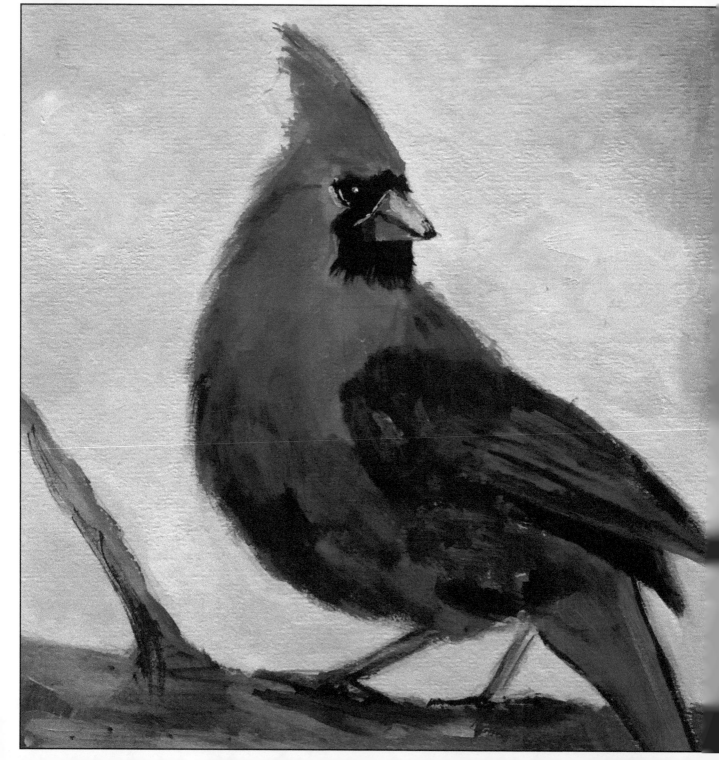

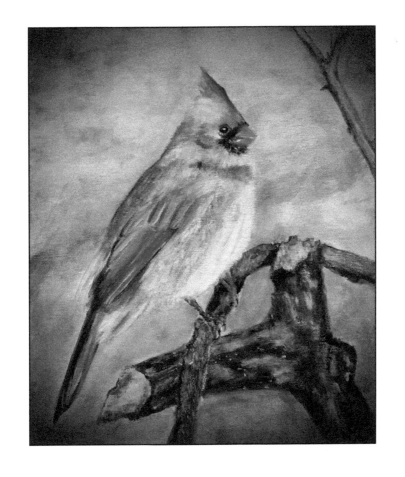

And so I fly closer
each day,
watching over you.

And you take each step with care.

Still not looking up, but I know
that you will. All things do,
eventually.

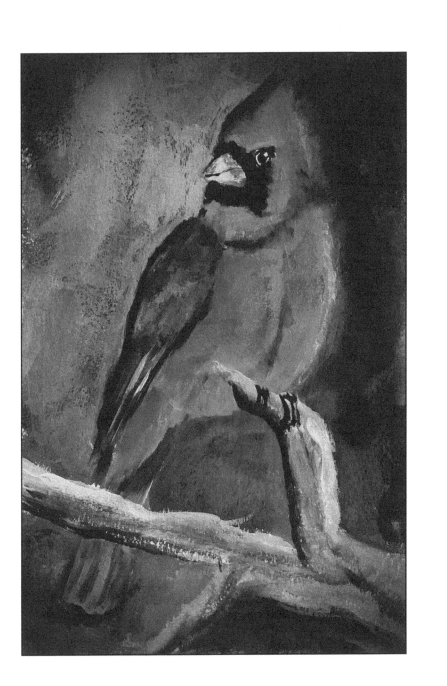

This freedom of wings and light!
I'm not sure what I was so
afraid of — what you are still
afraid of — it's not bad.

It's quite lovely.

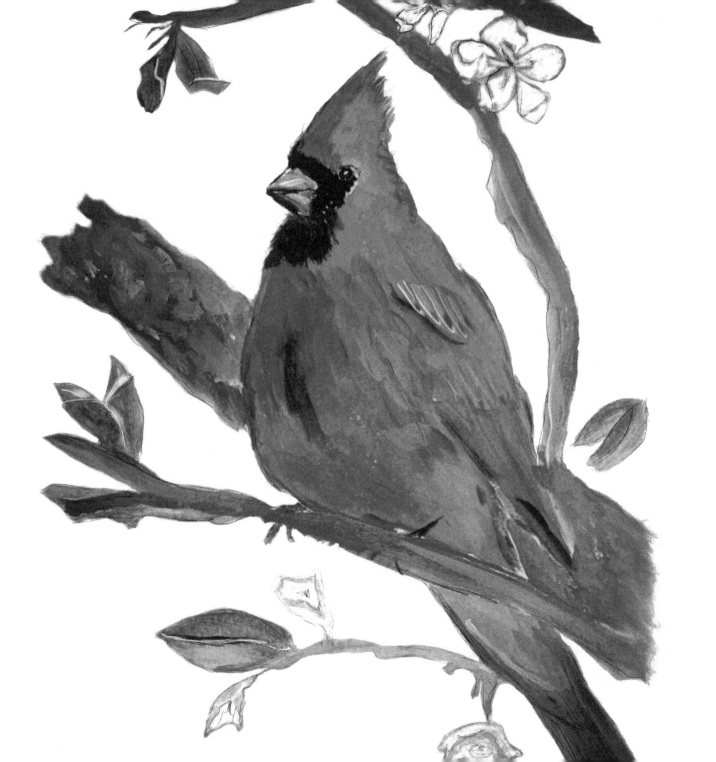

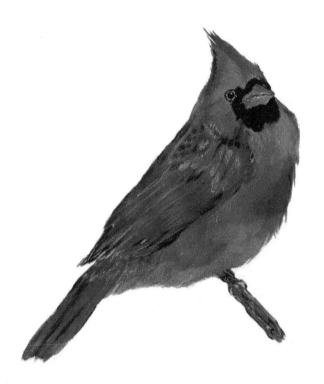

And I'm still with you.

I'm so lucky that I get to know that,
and soon you will too.

Soon you will see me.

Soon you will have the courage to look up.

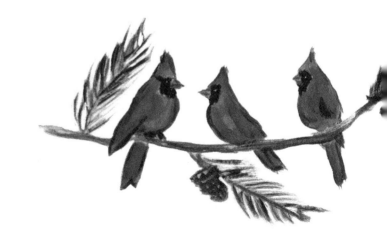

Still, I wait on wings.

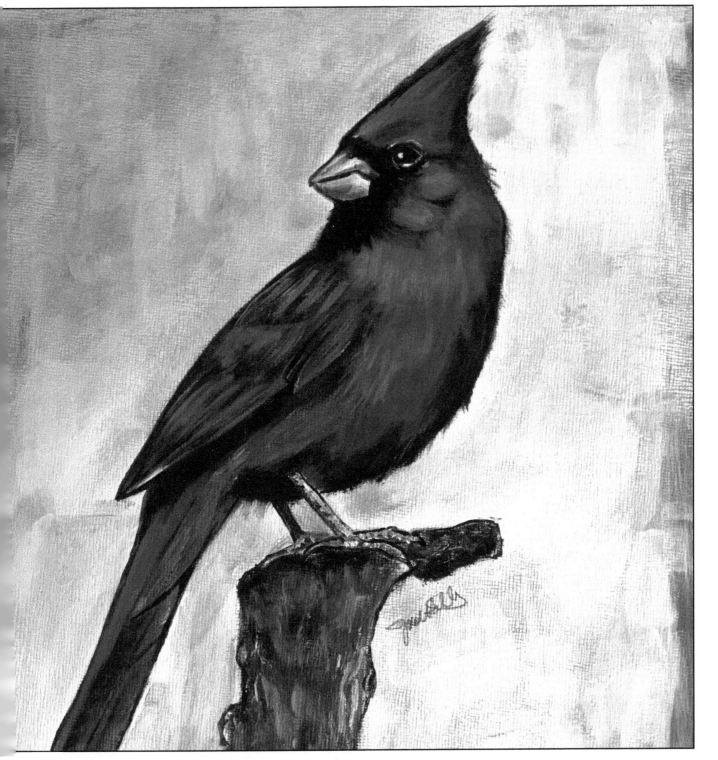

I float through the sky,
and remember.

The memories on wings
of you are like warm breezes,
even on the coldest of days.

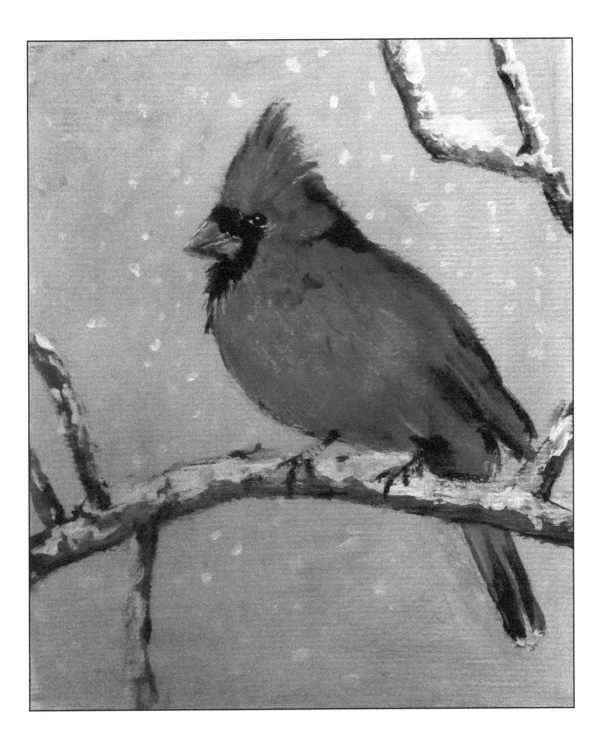

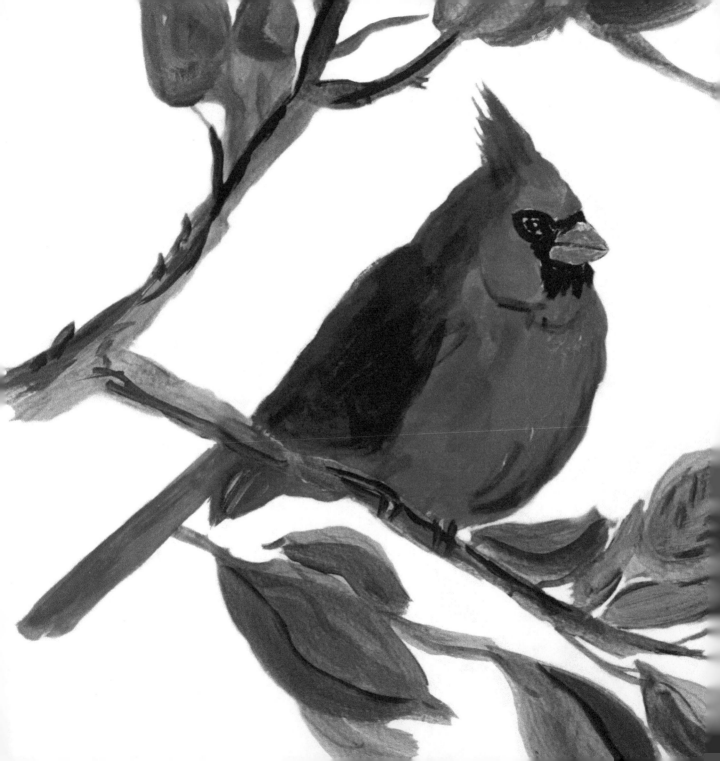

You still have the power to lift me.

And I want that for you.

So I return. Each day.

Fly by. Rest on branches.

Watching you.

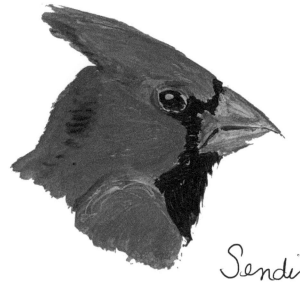

Sending my love.

So much love!

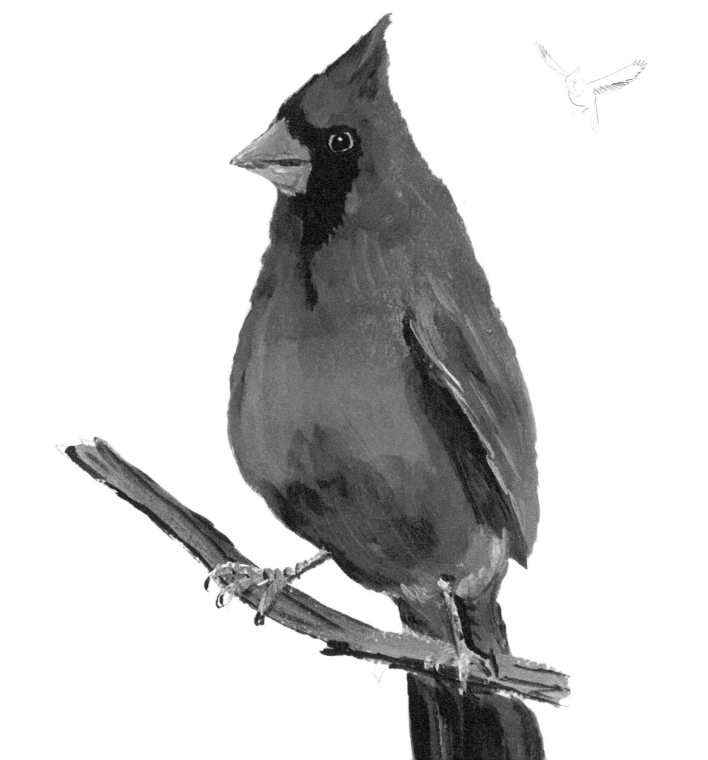

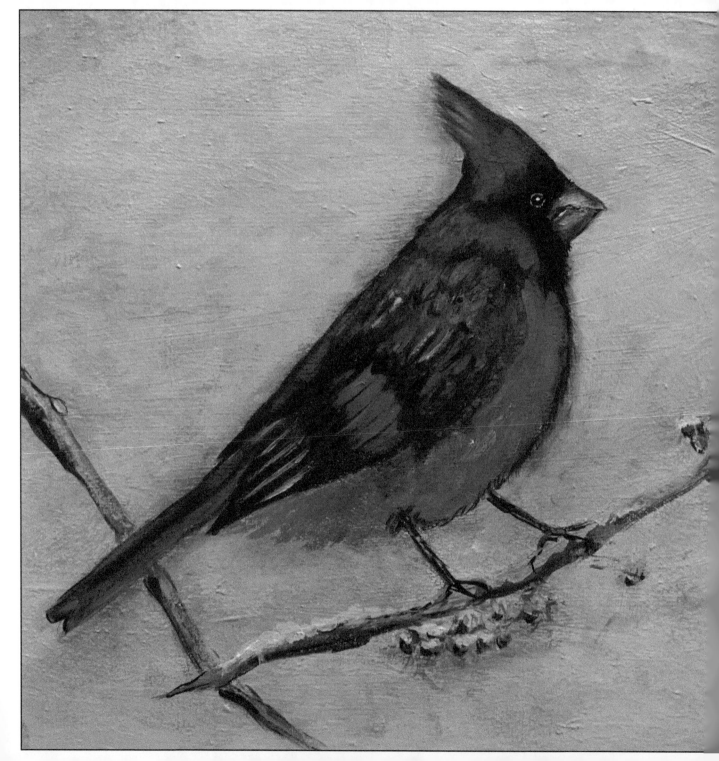

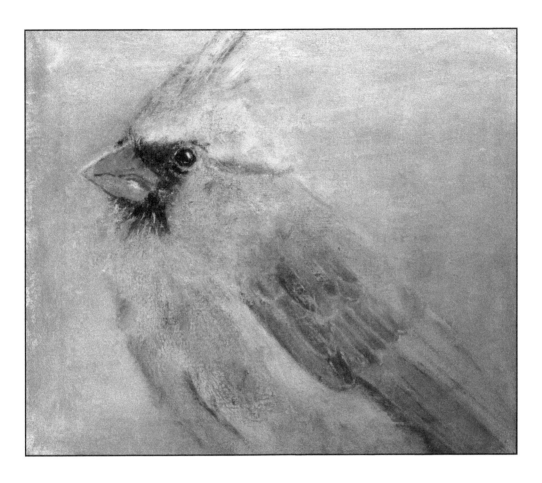

And you make it through each day,
foot by foot.

And I return.

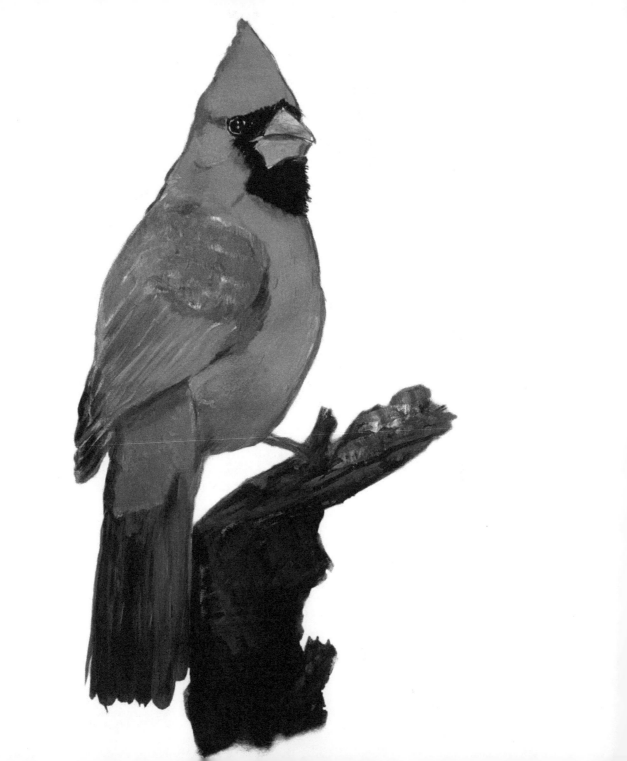

Flying over you now.

Can you feel it?

The warm breeze.

The love.

Look up. I'm here.

You're stronger now.
I can feel it each day.

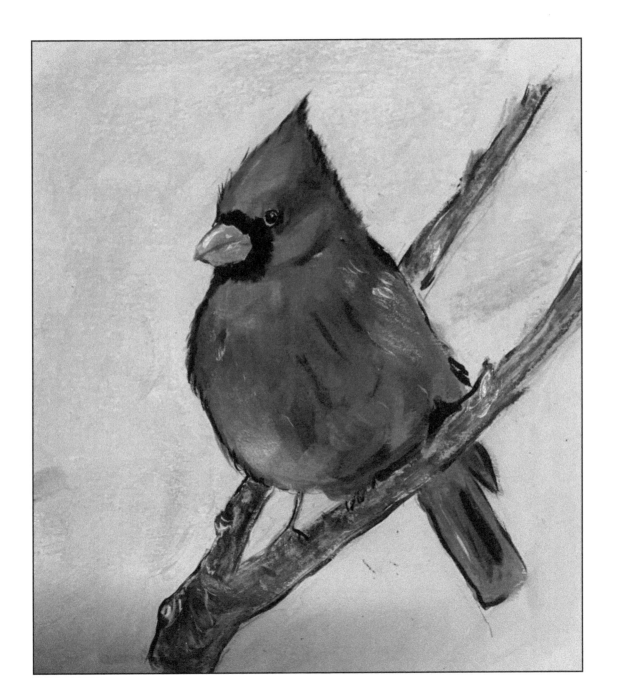

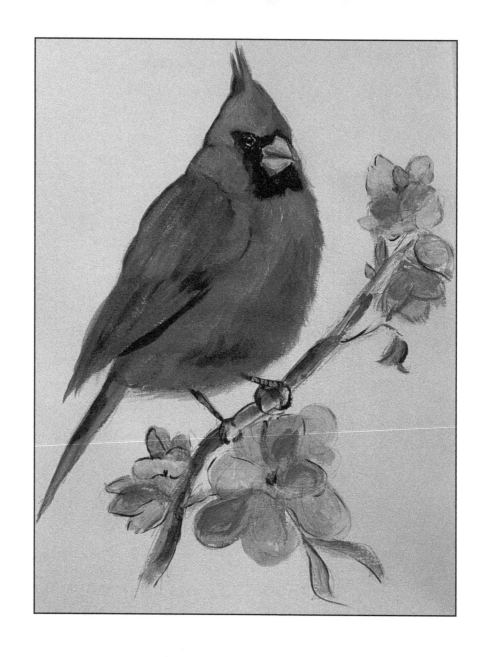

Look up. Here I am.

I know you're wondering if
you said goodbye. If you
said all there was to say.

If you loved me enough.

I'm no expert, but I have a thought.

I think love might be the colors
we give. And when I see my
feathers, in a color so bright
so red - that even the sun
can't dull - I think, I must
have been loved.

I know I was loved.

And I know it was you
who gave me this color,
the ability now to soar.

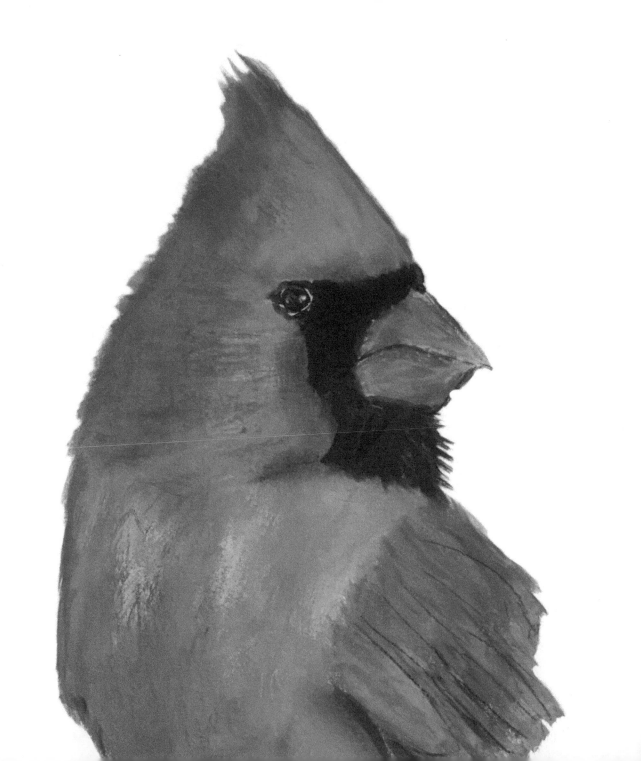

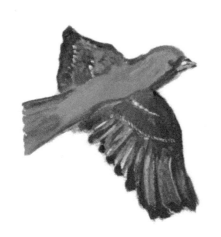

So look up.

See the flying rouge, and
know that I received all the
love you gave.

See the soaring red, and
know that everything is beautiful.

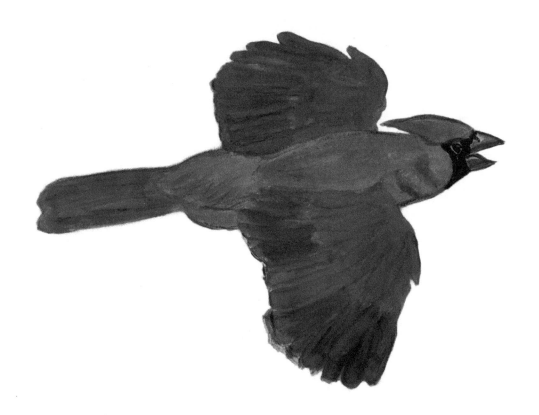

I know it's hard to believe.
Don't think I didn't have my
own doubts the first time
I saw the distance between
myself and the ground.

I was terrified. And I started to fall. Imagine that, a bird falling, with all that I've been given — I mean, I have wings.

I have wings. I was given
wings — it's hard not to
believe in that — so I started
to fly.

Believe and fly. And that's
when I saw you. Foot in
front of foot. So heavy.

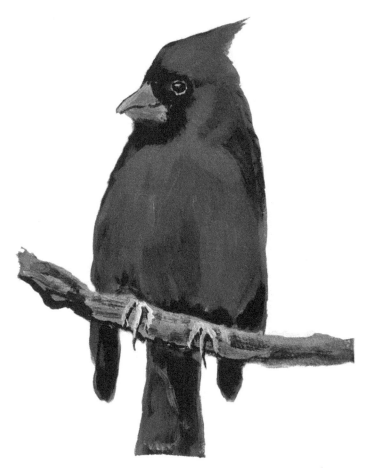

And I knew I only had
one thing to do, just get
you to look up.

And you will.

So I keep flying by. Landing near. Giving you all my lightness, all of my strength, all of my color.

Seasons have changed, and my color remains the same.

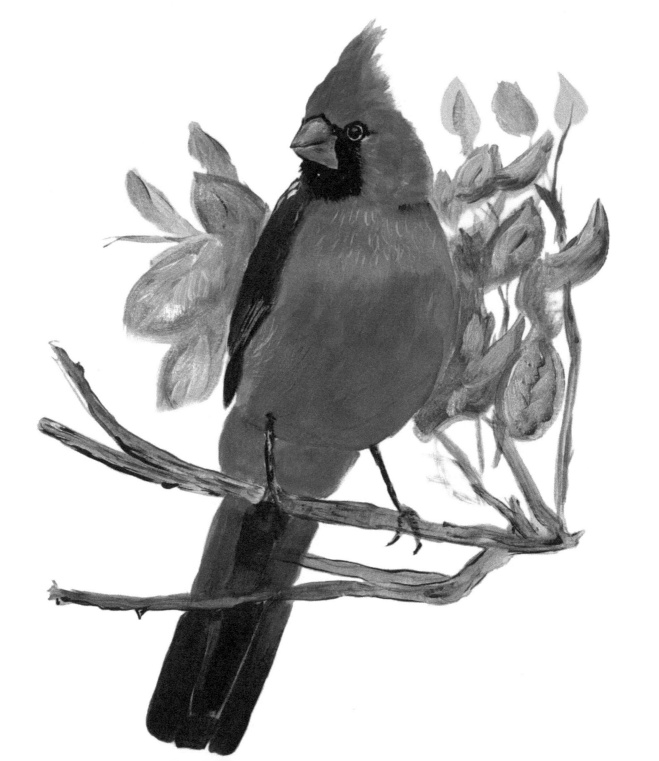

I thought I saw you move
a little lighter, so I
flew closer.

Closer still.

Resting right above you.

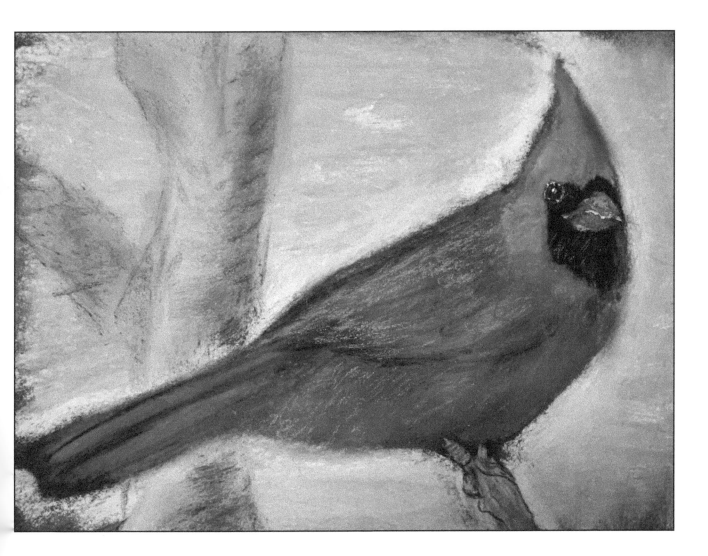

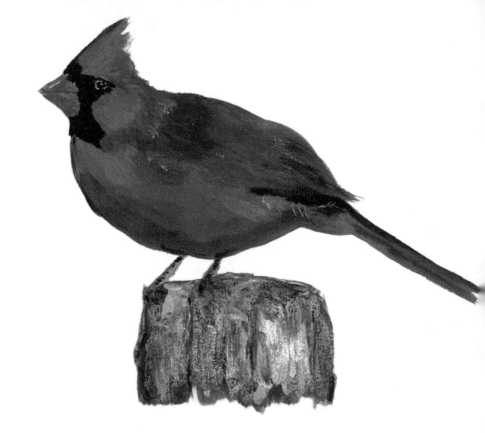

Wait, did you look up?

I think you looked up!

There again. You see me.
Don't you?

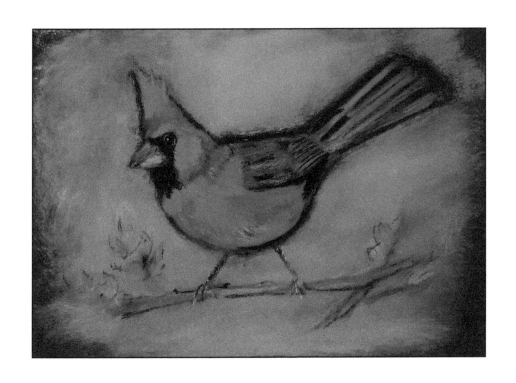

You do see me You know it's me.

I can see the air rise in
your chest.

I think that's hope.

I think ... I think I
see you smiling!

Are you smiling ??!!

I can't contain myself.
I fly. I flutter.

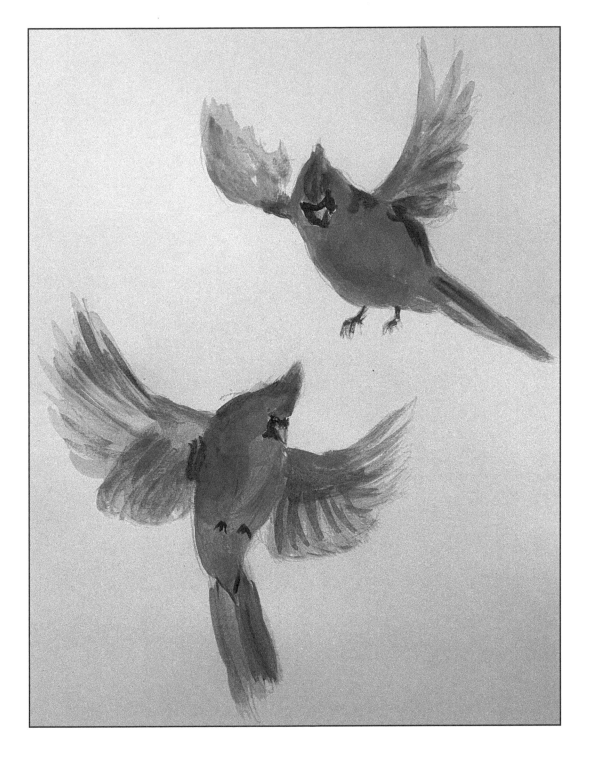

You smiled at me.
You know.

You saw the red, my red,
our red, and you know.

I know you know.
I know you believe.

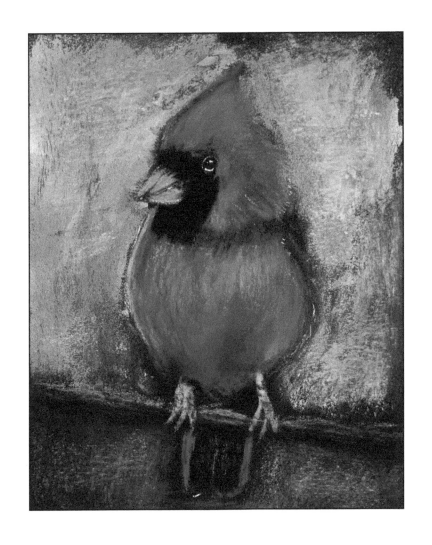

Everything is going to be OK.

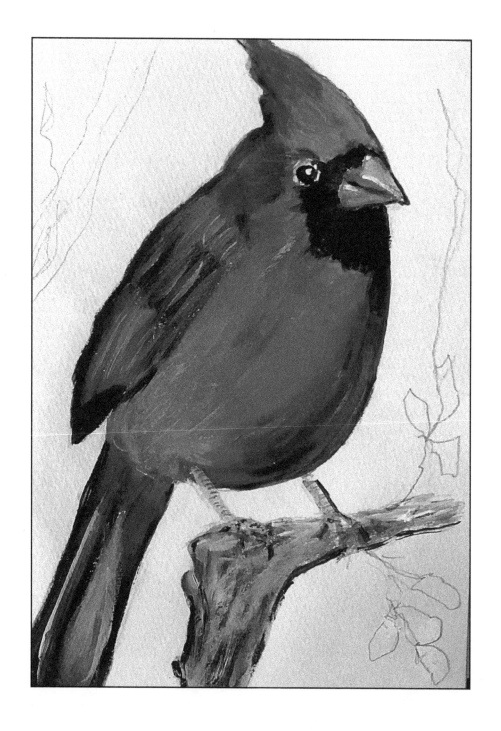

I'm still here.
You're still here.

I'm always with you.

That IS good!
Truly good.

Most things still are,
 you just have to look up.

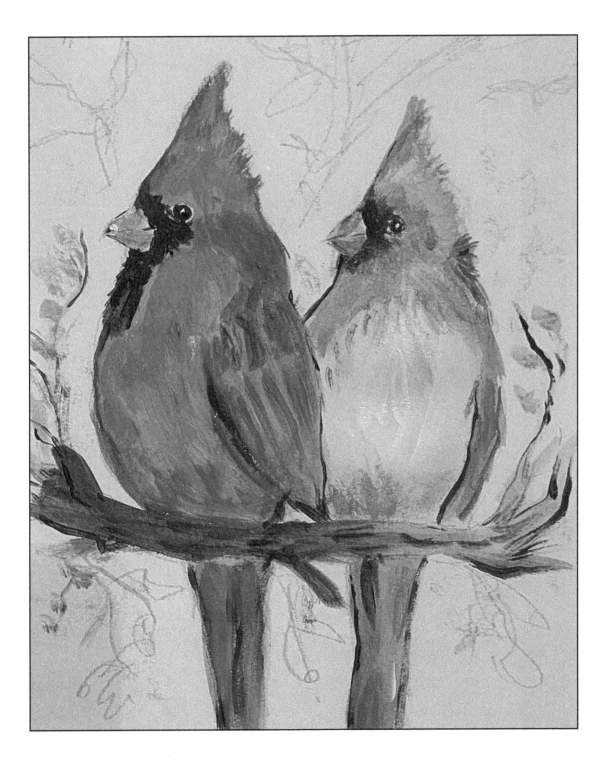

CPSIA information can be obtained
at www.ICGtesting.com
Printed in the USA
LVHW071914270122
709581LV00009B/486

9 780578 828299